Museum
Highlights

SCALA

MUSEUM OF LONDON

© Museum of London 2003, 2007

First published in 2003
by Scala Publishers Ltd
Northburgh House
10 Northburgh Street
London EC1V 0AT

Revised edition 2007

ISBN 978 1 85759 513 0

Edited and produced by
Scala Publishers Ltd
Editor: Miranda Harrison
Designed by the Museum of London
Designer: Veronica Rockey

Printed and bound in China by
Hong Kong Graphics and Printing Ltd

10 9 8 7 6 5 4 3 2

Front cover photograph
The City seen from Bankside,
c. 1820, Thomas Miles Richardson

Back cover photograph
© Museum of London

Contents

Director's foreword **4**

London before London 400,000BC–AD50 **7**

Roman London AD50–AD450 **13**

Saxon London AD450–1066 **21**

Medieval London 1066–1485 **25**

Tudor London 1485–1603 **33**

Stuart London 1603–1714 **37**

18th-century London 1714–1789 **45**

World City 1789–1914 **51**

20th-century London 1914–2000 **57**

Visitor information **64**

Director's foreword

London is one of the most vibrant, dynamic and culturally diverse cities in the world, and the Museum of London tells its story.

Cities are in a constant process of change, and city museums must reflect these changes to be responsive and relevant to the local, national and international audiences they serve. The Museum set a new benchmark in interpreting and displaying a major global city when it opened in 1976. Museum practice has changed a great deal in the intervening years, and the Museum of London has now embarked on a major gallery redevelopment programme to incorporate these new practices as well as new knowledge about London's history and heritage. At the same time the Museum will upgrade its learning facilities so that our links with adult learners and schools can be continued beyond the Museum's walls and school classrooms.

In 2005 the Museum opened its new medieval London gallery, which not only drew on 30 years of research since the original gallery opened, but also interpreted London's history during this period in the broader national and European contexts. The gallery also "speaks" to a broader audience including families and children, and this new gallery has been well received by our visitors. This is the first stage in an ambitious redevelopment programme.

In late 2009 the Museum will open a new series of galleries that depict London and Londoners since the Great Fire of 1666. It will provide a new opportunity to explore the past, illuminate the present and imagine the future. The current galleries tell the stories of London up to 1914, the start of the First World War. The new galleries will examine why and how London has changed and continues to change and, importantly, will draw out individual and personal stories against the backdrop of the major events and themes in London's history as a national capital city, the metropolitan centre of empire and the Commonwealth, and a global financial centre. London's history is a complex story and the challenge – one that most museums face – is to tell this story in an engaging and entertaining way that will stimulate our visitors to want to learn more about the city's history and heritage and to be inspired by the objects that they see on display in the galleries or on our web site.

This book highlights just some of the Museum's collections and permanent galleries. Many thousands of objects are in the Museum's care, however, and not everything illustrated will be on display. I hope this book will enhance your visit and enrich your understanding of London.

Professor Jack Lohman

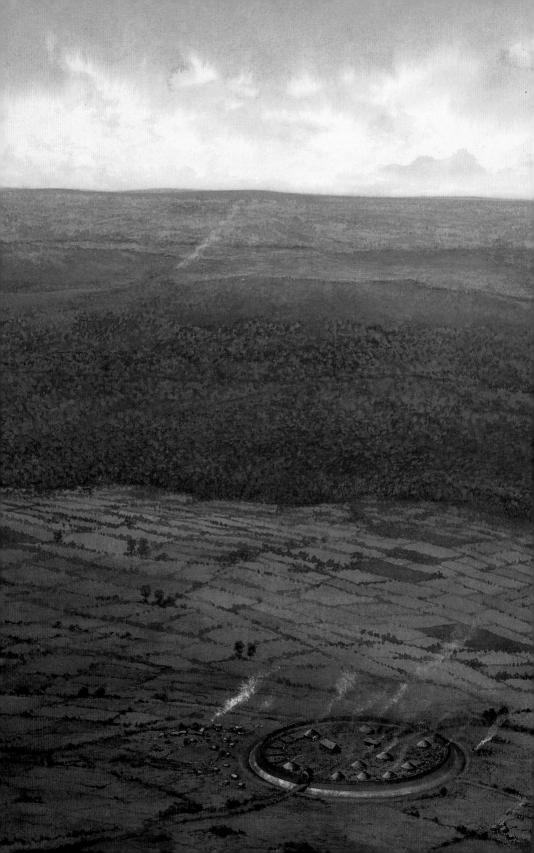

London
before London
400,000BC–AD50

The very first people to live in what is now London arrived about 450,000 years ago. For the next 400,000 years human presence was minimal. The Thames Valley was very different from today. The landscape was affected by Ice Ages, with open tundra conditions that alternated with warmer periods when forests covered the Valley. During this long period different animal species came and went, reacting to the changing vegetation.

The last Ice Age ended about 10,000 years ago. By this time modern people like us had arrived in Europe, and they rapidly exploited and changed their environment.

By about 6,000 years ago they were clearing the Thames Valley forests to provide pasture for their domesticated animals. They built large monuments as gathering places and for rituals. From this time the Thames started to be used both as a routeway and as a sacred river into which were deposited many beautiful objects as offerings.

As time went on, more sophisticated tools and weapons were made, first of stone and then of metals. People began to build permanent homes and farms, evidence of which has been found across London. In the last few centuries before the Roman invasion in AD43, there was less settlement, and it may be that the Thames was acting as a boundary between major tribal groupings.

Reconstruction of a fortified enclosure dating to around 1000BC. Queen Mary's Hospital, Carshalton, now stands on the site.

Flint hand-axe

This teardrop-shaped axe is made of flint. It was found in about 1912, underneath the Regent Palace Hotel in Glasshouse Street, Piccadilly. The flint is a beautiful amber colour. Hand-axes of this type were current in Britain between *c.*400,000 years ago and *c.*100,000 years ago. They were used all over the old world, from the southern tip of Africa to northern Europe. This particular axe, a superb example, would probably have been used to skin large animals, perhaps horse or even rhinoceros. It is unlikely to have been used for actually killing game, as the early humans hunted in groups, with spears. The hand-axe represents the end of the process, more akin to the role of the kitchen knife.

The simple appearance of a hand-axe belies the level of skill and precision required to make it. It was in fact a very highly worked and ingenious piece of equipment. Small chips of flint were removed to create long straight edges, used to cut through the hide and get through to the meat below the fat. The achievement of such a symmetrical, straight, flint edge was the result of generations of learning. Many of today's modern flint knappers have to work for ten or twenty years before they can achieve such precision.

The axe was held with the user's hand running along one edge, and the other long edge facing the meat.

In a modern-day experiment a butcher was given a deer carcase to dismember with flint hand-axes. Initially he couldn't see how he could possibly do it without his modern butcher's knives. But after twenty minutes or so he became extremely good at it, and at the end of the experiment the researchers had difficulty persuading him to hand the axes back!

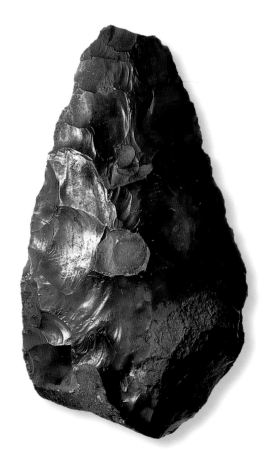

Flint hand-axe
*c.*400,000–300,000BC

Facial reconstruction

The woman on whom this reconstruction is based was excavated from a site at Staines Road Farm in Shepperton. She was found in the remains of a small, circular, religious site, buried deeply within one of the ditches. Her legs were drawn up to her chest and her arms tucked in under her chin, as though she were asleep. This was the general mode of burial adopted by many early communities. She was probably in her thirties when she died, and had been buried with various pottery bowls, flint tools and a wolf's head.

The discovery proved to be a good opportunity for the Museum of London to create a facial reconstruction. The work was carried out at Manchester University, and the first job was to reconstruct the skull. This was no easy task, as the skull was not in particularly good condition. Gaps in and around the nose and the eye sockets, for example, required skilful detective work. Due to careful research and scientific analysis, however, the resulting reconstruction must be a very lifelike impression.

By examining the way the skull was constructed and how the flesh was laid across it, certain anatomical details could be established, such as the full lips and large earlobes. The hair style, drawn back and tied in a bun at the nape of the neck, is pure invention, however, as we do not know how she would have dressed her hair, nor indeed its colour.

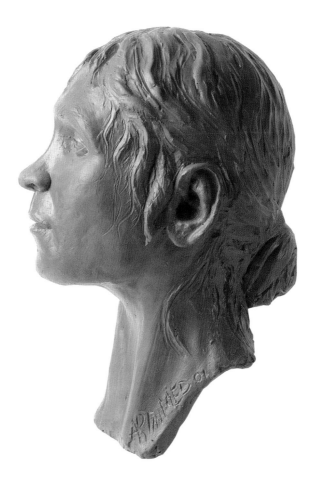

Facial reconstruction of a woman, c.3500BC

Pigmentation is very difficult to assess, so we don't know the colour of her eyes or her skin.

The woman would have lived roughly 5,500 years ago. By this time communities were no longer nomadic hunter-gatherers, and instead were beginning to settle in specific locations. They began herding cattle and sheep, and possibly even growing some of their own crops. The people of this period are often described as the first farmers, but their lifestyle is more likely to have been that of herders who did a small amount of cereal-growing.

Kew tankard

Made of oak and bound in bronze, with a small cast handle, this tankard probably dates from between about 300 and 100BC, and was found in the River Thames in the Kew/ Brentford area. It holds about four pints (two litres), so it would have been very heavy when filled. It is easy to imagine it being passed among aristocratic drinking partners at feasts, filled with mead, beer or watered down wine. Deemed worthy of being offered to the river, possibly as protection against flood, it now belongs to a group of extremely prestigious pieces of late prehistoric metal-work recovered from the river.

The tankard survived extremely well in the Thames, keeping its original metal patina as the water preserved the surface. On dry land it would have gone a nasty green colour and its form would have crumbled. The river has preserved many objects in good enough condition to go virtually straight into the display case. When this tankard was first found, just prior to 1890, it was said to be in superb condition. Next seen after the collector's death in 1911, the tankard had deteriorated somewhat as it had been stored in a garden shed. Unfortunately, scenarios like this were not uncommon among some Victorian collectors. Although they appreciated the objects they collected, often they did not give them proper care.

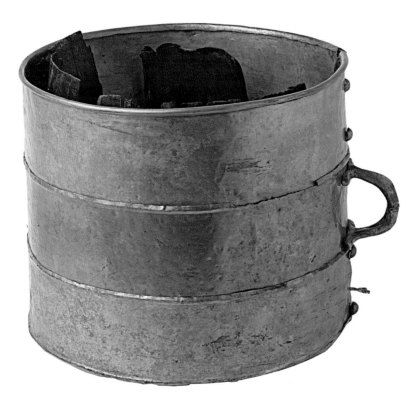

Kew tankard c.300–100BC

Two spearheads

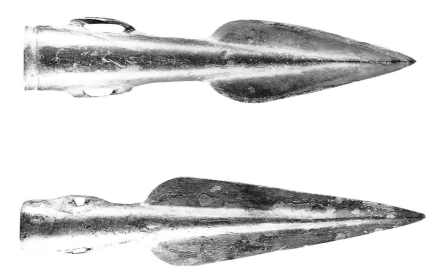

Spearheads, *c.*1400–1200BC

Bronze spearheads of the particular type seen here were used between 1400 and 1200BC. They are classified as side-looped spearheads, because of the loops on the side of the socket (the hollow base at the opposite end from the tip). The loops held a string or leather binding, which kept the spearhead attached to its shaft. When looking at spearheads like these, it is helpful to imagine them with a 5 or 6 foot shaft, probably of ash.

There is evidence that these spears were used. There are traces of wear along both of the blades where they have been sharpened, and there is also some localised traces of hammering, particularly on the sockets. When the spearheads were found, on the foreshore of the River Thames close to Vauxhall, their loops were blocked with silt, but under a microscope traces of a string made from lime tree bark were visible. Interestingly, there was absolutely no trace of wood within either of the sockets, indicating that the spearheads were not attached to shafts when they were buried. It has been suggested that the string was used to tie the two spearheads together, and that they were deliberately pushed, tip down, into the foreshore as a pair.

Huge numbers of metal objects have been recovered from the river, and this is an important part of understanding the prehistory of the lower part of the Thames Valley. Local communities were very much exposed to the rise and fall of the river level, and the Thames was periodically prone to flooding. Much of this great collection of prehistoric metalwork could have been offered to the river deity in an attempt to protect people against flood.

11

Roman London
AD50–AD450

The Romans were the first to build a major settlement at a suitable crossing point of the River Thames. Founded in about AD50, the town was constructed about seven years after the Romans first came to Britain. It was initially built like a frontier town with long narrow timber-frame houses, wooden boardwalks, and native roundhouses. The whole town was destroyed in a tribal rebellion led by Queen Boudica in AD60. Rebuilt as a traditional Roman town, Londinium became a prosperous trading centre at the heart of Roman communications and capital of the province of Britannia, with public building on a grand scale.

Roman London was made up of a wide range of differing nationalities. Native Britons were drawn to the new town, but others came from elsewhere in the Roman Empire, as administrators, merchants and members of the army. Latin was the official spoken language, although the origins of the name Londinium are probably pre-Roman.

Londinium maintained its predominance for the next 300 years and, although the town shrank in size, it remained the cosmopolitan centre of administration in Roman Britain. The city wall, built in about AD200, determined the shape of the city for the next 1,600 years. By AD410, however, the towns of Roman Britain were being threatened by Saxon raiders from across the North Sea. As the fifth century progressed, Roman London became a ghost town, with buildings falling into ruin.

Roman London as it would have looked in AD120.

Camomile Street soldier

This soldier's tombstone was uncovered in the nineteenth century in Camomile Street, in the City of London. His cloak is swept to one side so that his short sword and parts of his armour are visible. His hairstyle and clothes are typical of the first century.

He carries six writing tablets in his left hand. Unlike in other areas of Britain, such as the forts on Hadrian's Wall, soldiers were not based in London for defensive reasons.

Tombstone of a legionary soldier, first century AD

They were there to work for the governor, who needed a large staff to run the central administration. The writing tablets indicate that this soldier worked in a clerical position. It was Roman policy for soldiers not to be based in their own countries at this time, so he would have come from elsewhere in the Empire, maybe Germany or France.

The soldier represents the start of Roman London itself. As a newly created town, it owed much to the army, who were responsible for the initial town planning and whose engineers advised on building and engineering work.

Gold coins

Comprising forty-three gold coins (called *aurei*), this hoard was discovered in 1999. The coins span 109 years from the Emperor Nero to Marcus Aurelius.

The hoard was found in a wealthy residential building near the forum. It had been placed inside a small wooden box in a stone-lined area underneath the floor. The coins were clustered together as if they had been in a textile or leather bag.

These coins were not in everyday circulation. They may have belonged to a rich

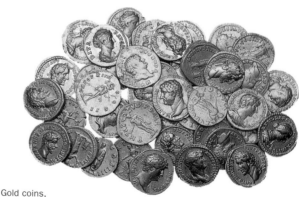

Gold coins, dating from AD65–AD174

merchant, banker or administrator, and were used for large business transactions to buy land, perhaps, or as bullion. Each coin represents the equivalent value of a Roman legionary soldier's salary for one month.

Port model

This model shows what the waterfront would have looked like in about AD100. It is based on a series of excavations along Lower and Upper Thames Street, which uncovered some 600 yards of Roman water-front. While in use, the original waterfronts gradually silted up and, rather than clearing away the silt, the Romans and later generations simply built new waterfronts out into the river. The Thames is now about 110 yards narrower than it was in the Roman period for this reason.

Here a new waterfront is being constructed out into the river. Building rubble and domestic rubbish were used to fill the gap between the old and the new waterfront. Buried in wet conditions for nearly 2,000 years, interesting objects such as leather shoes, which do not usually survive burial, have been preserved.

We know that the waterfront consisted of a heavy framework of oak timbers, with a road running along it. Behind this were warehouses. Their walls survived up to a height of about one and a half feet, and enough evidence was found to create a model of the buildings as they would have appeared, with stone walls, timber flooring, clay roof tiles and open-fronted shutters. The warehouses were used for storing goods imported from throughout the Roman Empire.

There was a bridge across the Thames, but little evidence of its appearance has survived. During excavations archaeologists found what is thought to have been one of the bridge piers, but the bridge shown here is based on other known Roman bridges. The boats are based on surviving examples excavated from the mud of the river. The large boat would have come from the Mediterranean and would have had a deep keel. The flatter, more barge-like boat would have been used for local river trade, and it is based on one that sank near Blackfriars with a cargo of ragstone. Used for all the main buildings of Roman London, as well as the city wall, ragstone was quarried in the Medway area of Kent and brought to London by boat.

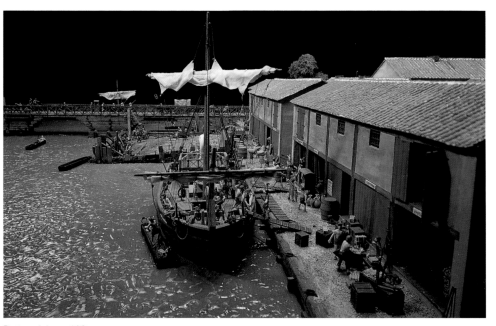

Port model, c.AD100

Roman dining rooms

The elegant reconstructed dining room, below, dates from about AD250 to 300. Its fine mosaic floor was found in 1869 during the building of Queen Victoria Street. Clay box flue tiles had been built into the walls. These allowed hot air from the heating system under the floor to flow up inside the walls, an early version of central heating. Underfloor heating became popular in the second and third centuries.

As very little furniture survives from Roman London, the items shown here are based on sources from elsewhere in the Empire. The jugs, pots and dishes, however, are all from Roman London and all date from the same period.

The second dining room shown here dates from about 200 years earlier. The two rooms clearly show how fashions changed. In the earlier room the walls are painted with deep terracotta panels, black columns and a bright yellow dado beneath, suggesting a marble effect. Colours had to be very bright, as rooms only had small windows. Two hundred years later the Romans were able to blow glass to make window-panes, and windows became much larger. In the later room the marble-effect decoration below the dado appears again, but the main design is far lighter, with scrolls, flowers and birds on a white background. The painted wall plaster from both rooms is based on fragments from London excavations.

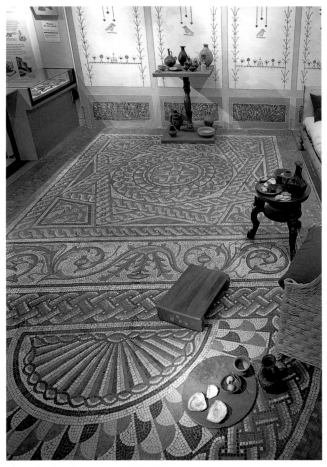

Reconstructed dining room, AD250–300

Reconstructed dining room, AD100

City wall

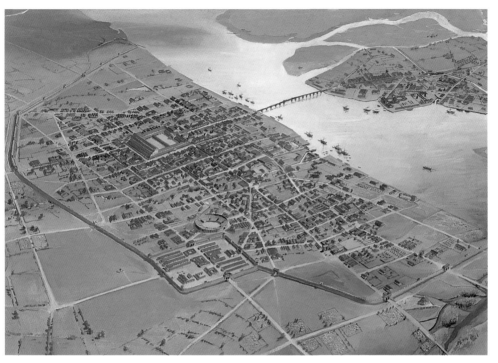

London as it would have looked in AD200

The Romans built the city wall in about AD200, and it is responsible for the shape of the City of London today. The wall stretched from modern day Tower Hill round to Blackfriars, for about 2 miles (3.2 kilometres). Visible outside the Museum of London is a thirteenth-century tower plus a nineteenth-century warehouse wall. It follows the precise line of the Roman city wall, which still exists below ground level. Much of the wall remained until eighteenth-century road-widening schemes, when parts were demolished. Other sections were incorporated into new buildings. A few sections still survive today.

The Roman wall comprised two parallel walls of squared blocks of ragstone, mortared together and infilled with rubble and mortar. The wall would have been about 20 feet high and 8 feet thick.

An earth bank was built up against the inside and a ditch constructed outside. Semi-circular towers were added to the landward wall in the late fourth century.

Temple of Mithras

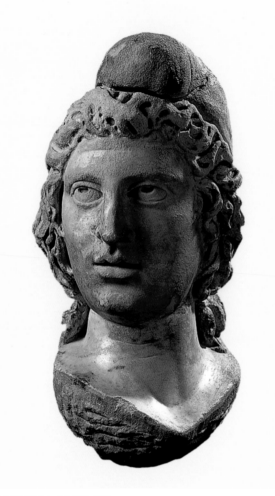

Head of Mithras, c.AD180–220

This head of Mithras was one of a fine collection of marble sculptures from the site. Mithras's eyes are rolling upwards – he is averting his gaze as he plunges a dagger into a bull (it was believed that the blood from the bull created everlasting life). He wears the Phrygian cap, a flat cap that came from the east.

The Mithraic religion was a mystery cult, a secret society only open to men. In the late-Roman period it was in direct opposition to Christianity, a religion open to all. The temple went out of use but the Mithraic sculptures survived, buried under the floor, perhaps as a votive offering to the spirits of the statues. Other sculptures found included the head of the Egyptian god Serapis and a head of Minerva. Serapis wears a bucket of corn on his head, as a symbol of fertility, while Minerva, as the goddess of commerce, was a very fitting deity for Roman London. The building was then used as a shrine to Bacchus, and sculptures of Bacchus were also discovered here.

A major archaeological excavation at Bucklersbury House, Walbrook, led to the discovery, in 1954, of a temple dedicated to the god Mithras. Worshipped by soldiers and merchants, Mithras was a god from the eastern part of the Empire. He was probably brought to London by soldiers working in the town.

Spitalfields woman

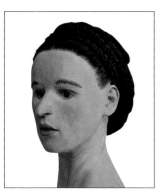

Excavations of a Roman and medieval cemetery at Spitalfields, in March 1999, uncovered a Roman limestone sarcophagus. What was exciting, on removal of the limestone lid, was the discovery that it also contained a lead coffin with a highly decorated lid. This style of burial suggested that this was the final resting place of someone important.

Inside the coffin was a skeleton of a young woman in her early twenties. Her head had been laid on a pillow of bay leaves, to give her a fragrant journey to the underworld. There was evidence of such fabrics as silk damask, as well as fragments of woven wool and gold thread which would have been sewn or woven into the silk damask. Her bones indicated that she was above average height for the period, and her teeth showed that she had a good diet during her lifetime. All these discoveries supported the theory that she came from a wealthy family.

The lid of the lead coffin was decorated with a scallop-shell design. It is thought that scallop shells were connected with the journey of the dead to the underworld; they are also associated with the god Bacchus and with Venus, who in later periods was always portrayed rising from the sea in a scallop shell.

The woman's age was determined from her bones, but her teeth revealed the most information. The closest modern DNA equivalent to samples taken from the enamel of her teeth was found in people from the Basque region of Spain. Isotope analysis of the tooth enamel showed that she was a first-generation immigrant, who had spent her early years in a climate warmer than Britain, perhaps Italy, Spain or southern France. The shape of her skull and her possible country of origin enabled a reconstruction to be made of her head, which was commissioned by the BBC for the TV programme, Meet the Ancestors.

Unfortunately we will never know this young woman's name, but all the evidence points to her being a member of a wealthy family of late-Roman London, who may have been merchants, landowners or administrators.

Above: Cleaning the lid of the lead coffin, 1999
Above left: Reconstructed head of the 'Spitalfields woman'.

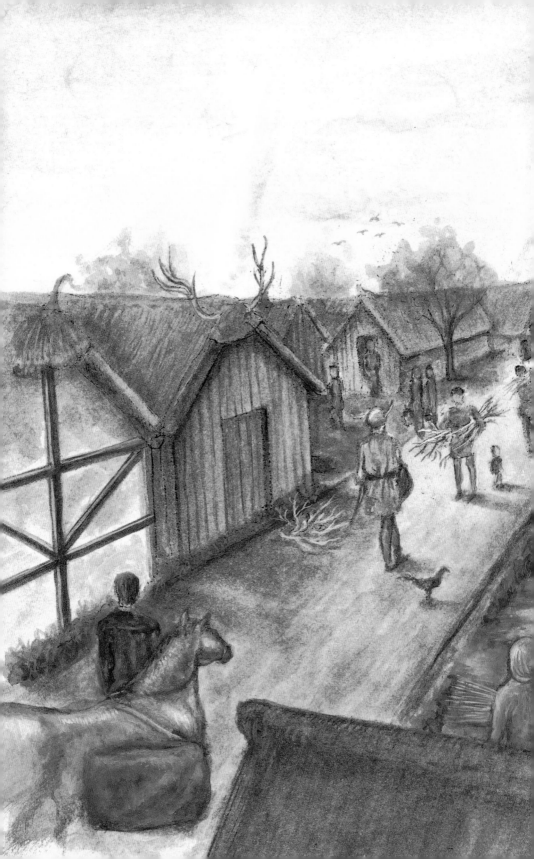

Saxon London

AD450–1066

In AD410 the Romans left Britain after nearly four centuries of occupation. As the Roman Empire collapsed, a new group of invaders came to Britain – the Anglo-Saxons from northern Germany. With little interest in the urban centres, they set up their own villages and farmsteads in the countryside and left the old Roman towns to fall into disrepair.

London was no exception. Its trade vanished, its purpose as a centre for administration disappeared and the inhabitants moved back to the land. Excavated Saxon objects in the Museum collections come from areas beyond the city walls, discovered in cemetery sites or little Saxon villages such as Hammersmith.

During the seventh and eighth centuries, however, the Saxons became town dwellers, and the old site of Roman Londinium was replaced by the thriving market town of Lundenwic, below modern Covent Garden and Aldwych. By the ninth century, Vikings from Scandinavia had discovered the riches of the town. They sailed in their swift ships up the Thames and organised raids that destroyed the trade on which Lundenwic depended.

Abandoned, London ceased to exist for a second time. It was re-founded within the old Roman city by King Alfred in the 880s. By this time the Vikings ruled the North and East of England as 'the Danelaw'. Alfred's successors gradually took over the Danelaw and ruled one single kingdom. London became one of the most important towns in this kingdom of England.

Street scene in Saxon London (Lundenwic), Kikar Singh, 2002 (detail)

Saxon brooch

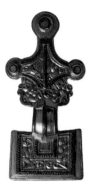

An early Saxon burial ground was discovered at Mitcham, south London, at the beginning of the twentieth century. It was customary to include grave-goods in a burial, reflecting the status and wealth of the deceased. At Mitcham a wide range of jewellery, weaponry,

Saxon brooch, early 6th century

domestic utensils and many other objects were found. One of the finest objects was this 'square-headed' brooch, cast in silver and then gilded. It was made in south-east England in the early sixth century. It was found in the grave of a young woman and would have fastened the garment in which she was buried.

Lundenwic

During the seventh and eighth centuries the Saxons established the thriving market town of Lundenwic, in the area we know as Aldwych, meaning 'old town'. We did not know its correct location until 1985, when it was revealed by excavations along the Strand, in Covent Garden and the Trafalgar Square area.

This is the view you would have seen had you looked out from a Saxon house on the site of today's Covent Garden Opera House. Today you would be looking towards the road we know as the Strand, with the river beyond. In Saxon times it was literally a strand – the beach. Ships came up with the tide to trade. As the tide went out goods were unloaded straight from the boat.

The same river that brought trading ships to London was to bring, in the ninth century, the Vikings from Scandinavia.

Reconstructed view from Covent Garden area of Lundenwic

King Alfred's penny

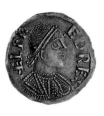

The king is on one side, looking like a Roman emperor with a diadem on his head. On the reverse is a monogram made up of the letters L-V-N-D-O-N-I-A, which was the Latinised name of Saxon London. The coin seems to be celebrating the fact that in 880, after battles with the Vikings, Alfred had succeeded

Silver penny issued by King Alfred the Great c.880

in taking back London.

According to contemporary accounts, Alfred founded the town of Lundenburg in 886. The suffix 'burg' indicates that it was a walled town, a fortified place, and it was within the old Roman city walls. Alfred laid out new streets, some of which survive such as Bow Lane and Cheapside. The continuous history of London as a flourishing merchant town can be traced from this point.

Stone from St Paul's

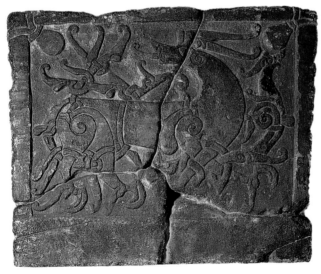

Tomb slab, early 11th century

Either a tombstone or part of a highly ornate tomb, this early eleventh-century carved stone once stood in St Paul's Cathedral. It appears to commemorate the burial of a Danish nobleman.

The Vikings had returned to Britain towards the end of the tenth century, to regain the Danelaw that Alfred had ceded to their predecessors. Ultimately, they wanted the throne of England and eventually they succeeded. In 1016 the Danish prince Canute (Cnut) was crowned King of England.

The stone is decorated with a beast, probably a lion, in battle with a serpent. The carving is in a particular style called 'Ringerike'. It combined Anglo-Saxon artistic styles with the art of Scandinavia. At the edge of the slab is an inscription, in the Old Norse language and in Norse runes. The runic alphabet had gone out of fashion in England by this time, but was still in use in Scandinavia. The Old Norse says: KINA: LET: LEKIA: STIN: THENSI: AUK: TUKI – 'Ginna and Toki had this stone laid'.

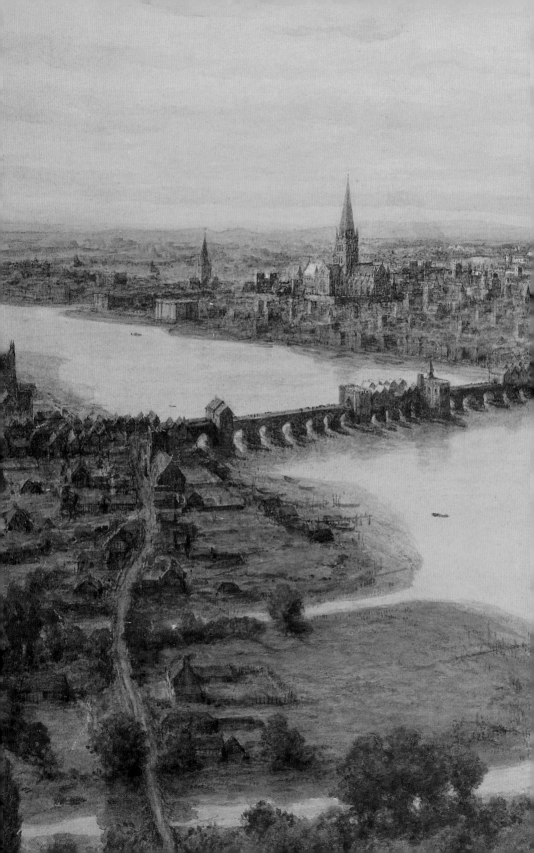

Medieval London
1066–1485

This section spans roughly 400 years, from the time of William the Conqueror and the Norman conquest in 1066 to the first of the Tudor kings, Henry VII, in 1485. During this period London grew substantially in size and wealth. It became the centre of England's trade, industry and royal government, as well as one of the greatest cities in Europe. Foreign visitors marvelled at the busy wharves and at constructions like St Paul's Cathedral and London Bridge. The city became an extremely cosmopolitan place, with people coming from all over Europe, both as traders and as settlers. Exporting wool and cloth, famous throughout Europe for its quality, England was able to import luxuries like wine, fine silks and satins, and fine metalwork from Germany. All of this commerce flowed through the port of London.

Central to life in London during the Middle Ages was the Christian church. The spire of St Paul's Cathedral dominated the skyline, towering for more than four hundred feet over the city. There were more than twenty-five monasteries, nunneries and friaries in and around the city. By the 1300s London was not a large place; you could walk across it in twenty minutes. However, crammed into that area, within the city walls, were something like 100,000 people. In 1348 came the Black Death – the plague. This and other disasters led to a dramatic fall in the population, bringing it down to about 50,000. The population stayed at about that figure for the next 150 years.

London in about 1400, Amadée Forestier, 1912 (detail)

The Black Death

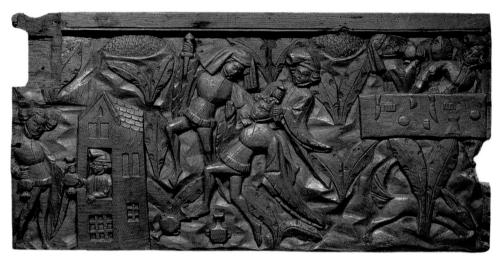

Panel from a wooden chest, *c.*1410

Found in a mass burial not very far from the Museum, a series of small lead crosses may commemorate one of the most horrific episodes in London's history. Bubonic plague swept across Europe from the east, reaching the outskirts of London towards the end of 1348. Figures suggest that perhaps one third of the population died. The plague became known as the Black Death.

The panel shown above is part of a carved wooden chest, dating from about 1410. It depicted scenes from *The Pardoner's Tale* (one of the stories in *The Canterbury Tales*, by medieval London's most famous writer, Geoffrey Chaucer). Chaucer lived through the Black Death, and the story is set during that time. The first part of the tale is missing,

where three youths drinking in a tavern hear that one of their friends has died of the plague. They decide to find Death and avenge themselves upon him. Out in the countryside they ask an old man where to find Death, and are directed towards a tree under which they find a heap of treasure. While two of them stay to guard it, the youngest is sent back to the town for food and wine. It is at this point that the Museum panel takes up the story.

The young man decides he would rather have the treasure for himself, so he buys poison and puts it in the wine bottles. The left-hand side of the panel shows him buying the poison. Meanwhile his two companions have decided it would be better to share the treasure two ways

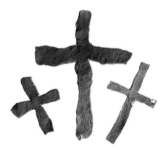

Lead crosses from a mass burial of plague victims at Greyfriars cemetery

rather than three, so on his return they attack their friend with daggers. The murder is depicted in the middle of the panel. In the final scene the two sit down and drink the poisoned wine, as seen on the right-hand side. In Chaucer's text the Pardoner, narrating the tale, concludes with the moral of the story – 'greed is the root of all evil'.

Leather shoes

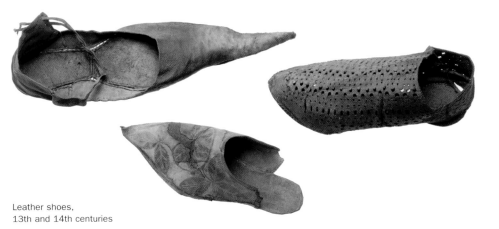

Leather shoes,
13th and 14th centuries

Archaeological excavations along the waterfront of medieval London have produced many examples of well-preserved leatherwork. Using modern-day conservation techniques, shoes such as these can be preserved and stitched back into shape. This allows us to see changes in fashion – most obviously when the rounded toe was fashionable, and when the pointed toe was in vogue.

The long pointed-toe version, called a 'poulaine', was particularly popular in London in the 1380s. The name meant 'Polish' shoes, and it seems that this was meant to imply a general sense of the exotic, rather as the word 'Bohemian' is used today. Stuffed with moss or hair, the toe could be up to 4 inches (10cm) long.

As with modern fashions, styles came back but never in quite the same form. The pointed toe was fashionable in the Middle Ages at three different periods: during the thirteenth century, in around 1380 and again about 100 years later.

It was not just the shape that made a shoe fashionable, but also the way it was decorated. The decoration could be very ornate and might be cut-out, incised or coloured. Unfortunately burial in the ground has destroyed any colour the leather had. Most highly decorated shoes were worn by fashionable young men, like those shown on the wooden panel opposite. Women usually wore full-length skirts, which would have hidden their shoes from view.

Pilgrim badges

In 1170 Thomas Becket, the Archbishop of Canterbury, was murdered on his way to a service in Canterbury Cathedral. He was to become a popular saint in London, as he was born and brought up in the city. Visiting Becket's shrine in Canterbury became a popular pilgrimage for Londoners.

Visitors to Canterbury could bring back pilgrim badges representing some of the things they had seen there, and the Museum has a collection of these little badges which were mass-produced in a cheap tin-lead alloy, dating from the thirteenth to the early sixteenth century.

One of the most impressive badges in the collection is a miniature version of Becket's shrine – you can see its architectural framework. The Archbishop died from a blow to the head. His shrine contained a fragment of his skull, enclosed in a heavily gilded and jewelled reliquary in the shape of his head and bust. The badge depicts the saint's head in the middle, wearing his archbishop's mitre.

Some badges represent just the jewelled bust without the architectural frame. At the bottom apears the saint's name: 'T:H:O:M:A:S'.

Another badge shows the ship that brought Thomas back to England from exile in France in 1170, shortly before his death. Thomas, in his archbishop's robes, is shown standing on the deck.

These badges were more than just souvenirs. They were believed to hold something of the saint's power and so could protect the owner from misfortune.

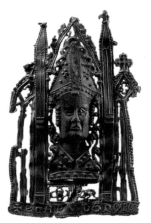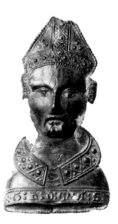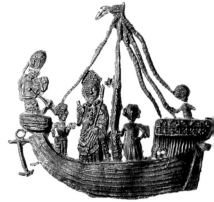

Pilgrim badges,
mid to late 14th century

False dice

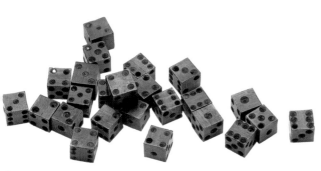

False dice,
late 15th century

In the Museum's collection are twenty-four tiny bone dice, along with a little pewter shaker that was found with them. They were discovered on the Thames foreshore by someone looking for artefacts with a metal detector.

On closer inspection, they turned out to be 'false' dice – some were incorrectly numbered while others were found to be weighted in favour of a particular number. Three have dots numbering 1 to 3, and then 1 to 3 again, rather than the usual 1 to 6. Another three are numbered 4 to 6 and 4 to 6 again, so that every throw would give a high score. Others have the right number of dots in the right places, but X-rays revealed that they had been weighted. In each case, one hole had been drilled out slightly and filled with mercury, to make the die tend to fall on a specific number.

False dice like these were known in later times as 'fulhams', because the riverside village of Fulham was apparently notorious for crooked gaming and dice-sharps.

Reliquary pendant

While pilgrim badges were cheap enough for most people to buy, actual holy relics could be purchased only by the very wealthy. This was not just a way to represent religious devotion, but it also helped to assert financial status and position in society.

One of the most important relics of medieval times was a fragment of wood believed to have come from the cross on which Christ was crucified. One of these precious relics is seen here, enclosed in a small gold pendant shaped as a cross. It is just 2 inches (5cm) high, and was probably worn on a chain, or possibly hung from a set of rosary beads.

The pendant is hinged at the bottom, opening up to reveal a piece of wood embedded in wax. We don't know where the wood fragment really came from, but the pendant was no doubt of immense value to its owner. Made of gold set with garnets, its enamel decoration shows the Crucifixion on one side and the Virgin and Child on the other.

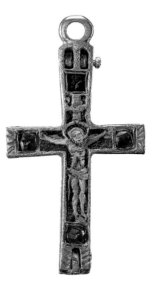

Reliquary pendant, 15th century

The 'Common Chest'

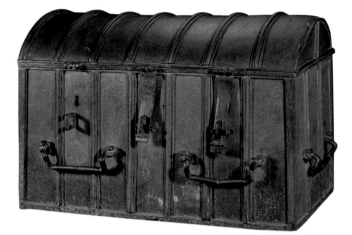

This chest or strongbox, made of iron plates, was kept in the City's Guildhall for many years. It is believed to be the medieval 'Common Chest', made to hold valuables and vital City property. A document dating from 1427 refers to the Chest and its six keys, each of which was held by a member of the City's Corporation. All six men would need to be present to oversee the opening of the chest.

The 'Common Chest', early 15th century

Guildhall statues of Virtues

By 1430 work was mostly completed on the construction of a new Guildhall building for London, which was the centre of London's local government. Most of the building has survived and is still in use today.

The façade of the main entrance was decorated with statues in niches. Four statues surrounded the doorway, representing the four 'Virtues'. A later writer identified them as Discipline, Justice, Fortitude and Temperance, although traditionally the four cardinal virtues included Prudence rather than Discipline. Each of them trampled a conquered 'Vice'. In the past, the two figures shown here have been

called Discipline and Justice. They more probably represent Temperance and Fortitude (with a shield at her side).

In the late eighteenth century the Corporation of London decided to rebuild the porch, and thus demolished the medieval façade. The discarded statues were bought by a sculptor who kept them in his studio, drawing sketches from them and using them as teaching aids. He may have re-sculptured parts of them too, as it looks as if the faces of the Vices were re-worked.

Lost for many years, the statues were recovered in the

1970s when Caroline Barron, now Professor of London History at Royal Holloway, University of London, was doing some research into the history of the Guildhall on behalf of the Corporation. Her research led her to discover the statues at the bottom of a garden in Wales. Despite being partly buried in dead leaves they were immediately recognisable from sketches dating from before the demolition of the Guildhall façade. All four were brought back to London and became part of the Museum collection.

Right: Statues from the medieval porch of the Guildhall, early 15th century

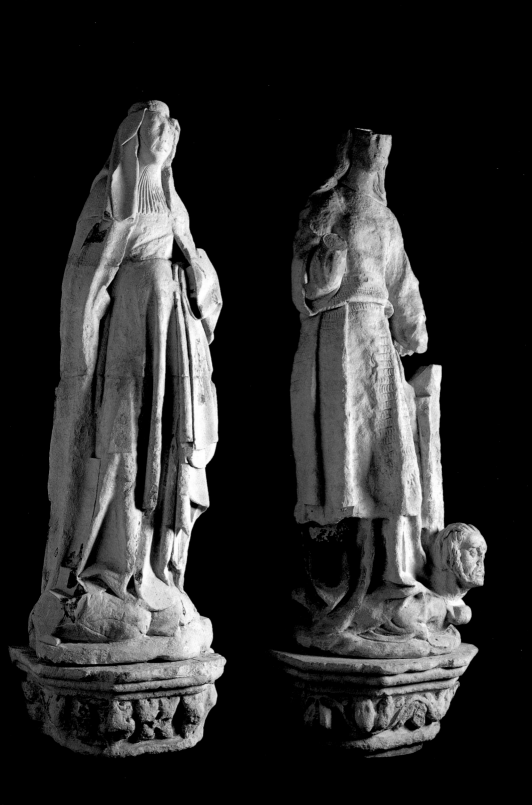

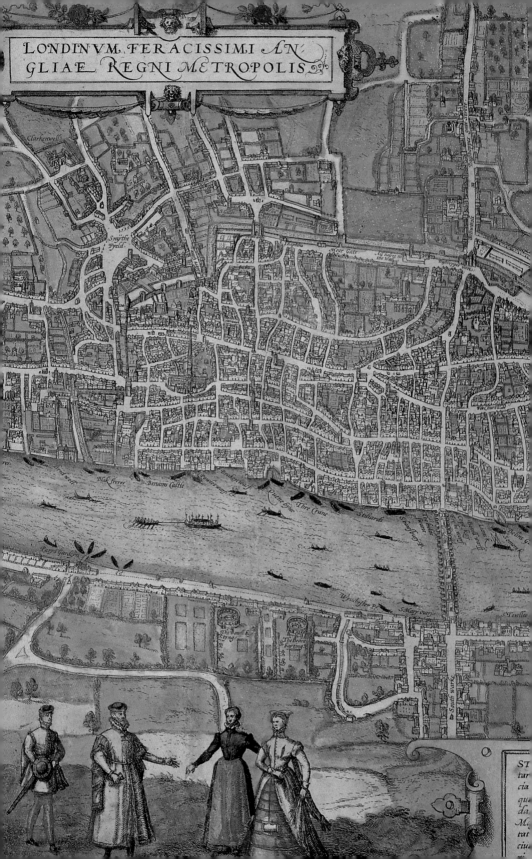

LONDINVM FERACISSIMI AN-
GLIAE REGNI METROPOLIS

Tudor London
1485–1603

This period begins with the coronation of the first Tudor king, Henry VII, in 1485 and it is dominated by the long and colourful reigns of Henry VIII (1509–47) and Elizabeth I (1558–1603). Although a period of relative political stability, it was a time of profound religious change. With the Reformation and the Dissolution of the Monasteries, property passed from religious hands to secular hands. Not only did this have a major impact on the economic structure of London, it also greatly altered the fabric of the city. Henry VIII began massive building programmes for royal residences such as Bridewell, Greenwich and Hampton Court.

Under Elizabeth I, London became the centre for overseas exploration and trade, literature and the arts. At the same time there was a decisive shift away from London as a centre for the importing of luxury goods. The manufacture of such goods in London increased significantly, and the city became a major exporter.

By the beginning of the Tudor period, London was divided into three distinct urban settlements – the City of London, within the city wall; Westminster, to the west; and Southwark, across the Thames. It was to be a period of huge growth for the city. At the start of Henry VII's reign, London was already three times the size of Bristol or York, its closest rivals, with a population of about 30,000. Yet, by the time of Elizabeth's death, the population had quadrupled to around 200,000.

The earliest printed map of London, 1572 (detail)

Copperplate maps

Below are two copperplate maps, positioned to show how one map leads into the second. They are part of a series that fitted together to form a map of the entire metropolis, providing a vivid image of sixteenth-century London. It is thought that there were originally fifteen sections altogether.

Printing plates were normally discarded once the surface had worn away, but these survived because copper was considered to be a good medium for oil painting. Both of these plates have paintings on the reverse. A few years ago another plate came to light in a German collection, which fitted to the bottom of the two shown here.

The top plate shows an area outside the city wall. Washerwomen are laying out their clothes in Moor Field, while above them archers practise their skills. Two windmills stand on mounds built from human bones and refuse. On the right-hand side, next to The Spitel, a gun is being fired in the artillery yard. Cannons were trundled up to here from the Tower of London for weekly artillery practice.

The second plate shows a section of the city of London within the wall, incredibly congested and built up, where rich and poor lived in close proximity. If you look very closely indeed, you might just see details such as Cornhill running down to the Poultry, Cheapside and the Cheapside conduit. To the bottom of the conduit are water carriers' barrels. People did not drink water if they could avoid it – it was mainly used for washing, or for mixing to make ale and beer. These two plates are the earliest visual evidence we have of such aspects of London life.

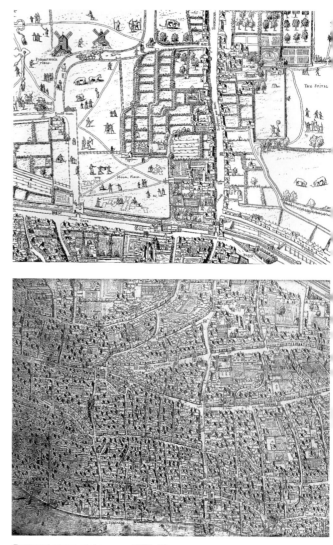

Engraved copperplate maps 1553–59

Nonsuch Palace

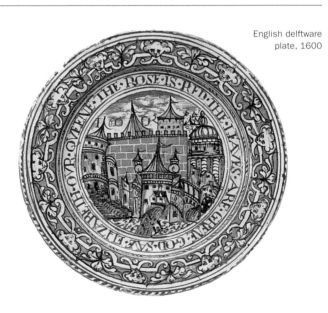

This large carved stone has an unusual history. Originally it was a painted ceiling boss at the wealthy Priory of Merton in the village of Cuddington, Surrey. The large hole in the centre indicates where an iron rod held the boss to the ceiling, and there are faint traces of red paint or pigment.

Under Henry VIII, England underwent an enormous religious upheaval. Breaking with the Roman Catholic Church, Henry formed the Church of England with himself as supreme head. He also distinguished himself from any other Tudor monarch through his major programme of refurbishing the royal palaces, together with the building of new manors and castles. The prime land on which Cuddington village and priory were built was considered by Henry VIII to be the perfect location for a royal hunting park and a new palace. The palace was to outdo all others – hence its name, Nonsuch. It was decreed that the priory be demolished. Much of its stone, including this ceiling boss, became the foundation rubble of the new palace. Within weeks of the completion of Nonsuch palace, in 1547, Henry was dead. The site became used as farmland and the palace was forgotten. Its remains lay hidden until the 1960s. All the finds recovered from the site are now in the Museum.

Medieval ceiling boss used as foundation rubble for Nonsuch Palace.

Delft plate

English delftware plate, 1600

Dated 1600, this splendid plate features an inscription in honour of Elizabeth I: THE ROSE IS RED . THE LEAVES ARE GREENE . GOD SAVE ELIZABETH OUR QUEENE. The image in the centre is a stylised depiction of a cityscape, probably London. It was made in Aldgate and is the earliest known dated and commemorative piece of English delftware. It is also the earliest known piece in England with an inscription.

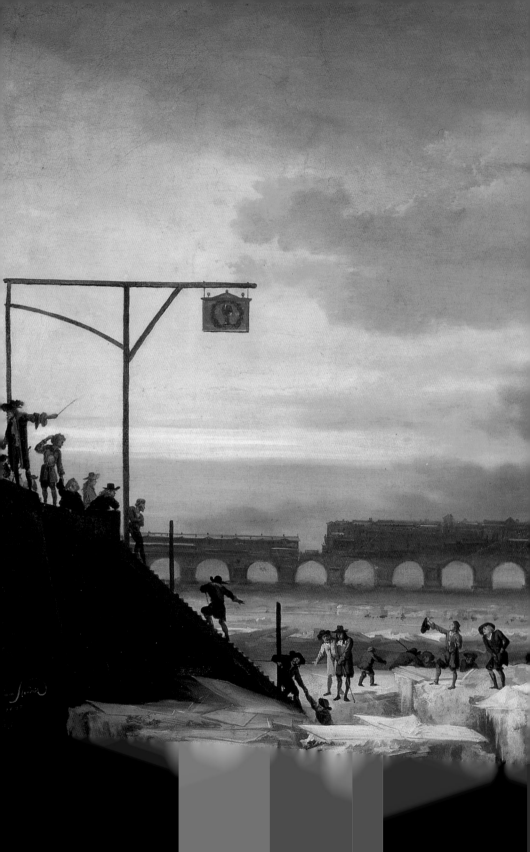

Stuart London
1603–1714

This section runs from the accession of James I, in 1603, to the death of the last Stuart monarch, Queen Anne, in 1714. The period that began with widespread belief in the 'divine right of kings' saw the execution of the monarch and the country made a Republic. With the Restoration of the monarchy in 1660 the Puritan era ended, and theatre, sports and dancing were revived. Major economic and constitutional transitions affected the inhabitants of London too. Banking and insurance companies were formed (for example, the Bank of England, established in 1694). Professional societies, such as The Royal Society which was founded in 1660, also flourished at this time. Technological advances played their part in the social history of Stuart London, such as the advent of clear crystal glass, made by George Ravenscroft, and John Dwight's experimental porcelain.

After the Great Fire of 1666, London's appearance changed considerably, partly due to a series of Rebuilding Acts. The most important of these was passed in 1667, to ensure that buildings were constructed in a way that reduced the risk of their being a fire hazard. Streets were widened and most new buildings were now made from stone or brick. London was no longer a timber-framed medieval structure but a modern city.

In 1707 the Act of Union, passed by an increasingly powerful Parliament, brought England and Scotland together to form Great Britain.

The Frozen Thames Looking Eastwards Towards Old London Bridge, 1677 (detail) Abraham Hondius, *c.*1625/30–1691

The Cheapside Hoard

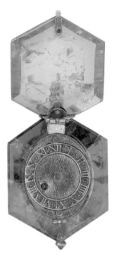

Gold watch set in emerald *c.*1600

Discovered in Cheapside in 1912, this dazzling hoard forms the largest collection of Elizabethan and Jacobean jewellery in the world. Over 400 pieces had been buried. The jewellery dates from between 1560 and 1630, and it would have been worn by the prosperous merchant class.

Along the south side of Cheapside there was a series of goldsmiths' shops, either owned by or leased to goldsmiths, and the hoard is thought to have been part of a goldsmith's stock-in-trade. The reason for its burial remains a mystery, but it was probably buried in the early part of the seventeenth century.

A star piece of the collection is a huge hexagonal emerald set with an elaborate gold watch face. The emerald was imported from Columbia, and the gold watch was probably set into it by master jewellers in a workshop in Geneva.

The collection also includes cameos (stones carved in relief showing classical figures) and intaglios (stones cut or incised). Classical motifs and designs were extremely popular at this time.

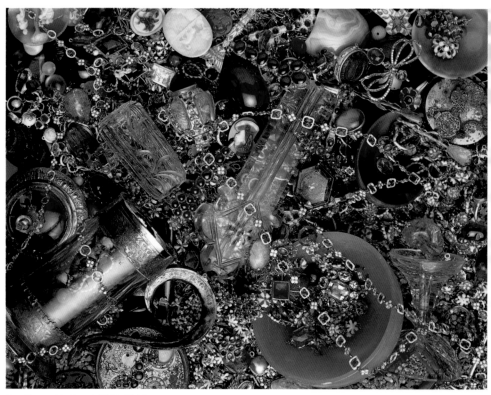

The Cheapside Hoard 1560–1640

Health and Medicine

'Melancholy Madness', a stone figure from the Moorfields Bedlam Hospital, *c.*1676

The increasing numbers of contagious diseases – syphilis, smallpox, tuberculosis and, especially, plague – suffered by Tudor Londoners remained a major cause of concern during the Stuart period. Common illnesses such as a variety of fevers (often called 'the sweats') could turn nasty, while epidemics of plague and smallpox had devastating effects. Local herbal remedies brought some relief but could not stop the outbreaks of infectious diseases. Bloodletting – cutting veins or using leeches – remained the standard treatment.

Increasing scientific knowledge began to be put into practice alongside the more traditional approaches to medicine. In 1628, William Harvey published *De Motu Cordis et Sanguinis*, announcing his discovery of how blood circulates around the body, pumped by the heart. Twenty-five years later Nicholas Culpeper published *The English Physician Enlarged*, or *The*

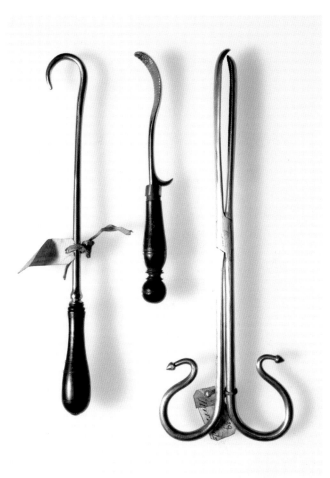

Surgical instruments, 17th century © Royal College of Physicians

Herbal, which still forms the basis of herbal medicine in the English-speaking world.

For those suffering from mental ill-health, the best known and largest asylum was Bethlem Royal Hospital, popularly known as 'Bedlam'. In 1676 Charles II opened a new building in Moorfields, which was set in gardens and based on the Tuileries Palace

in France. Now a place of display, the asylum had become one of London's main tourist attractions. On Sundays, the public was admitted for a fee to watch the inmates. There were those who objected to such treatment of the mentally ill, but the practice of public viewing did not end until the early nineteenth century.

Cromwell's death mask

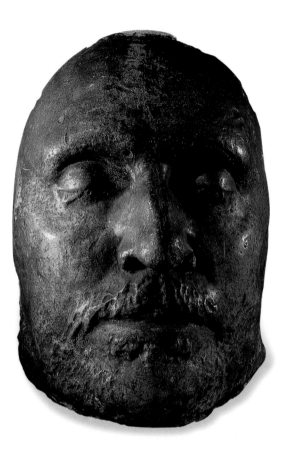

Cromwell's death mask, 1658

Ages, were able to settle and work in London; science and other aspects of intellectual inquiry were encouraged and stimulated; and, perhaps most significantly, England was very successful in its foreign relations. The balance of power in Europe was weighted very heavily in England's favour. Much of this was attributed to Oliver Cromwell's success as a statesman.

By the time of his death in 1658 Cromwell had become, in effect, a king. His funeral was magnificent. There were sumptuous processions and the crowds were enormous. Somerset House, where his body lay in state, was decked out with 2,000 banners and textile hangings. One of these is in the Museum – an escutcheon (coat of arms) is painted on taffety, a type of silk, with the arms of Cromwell and the Commonwealth.

Like monarchs before him, Cromwell's body was embalmed. By pressing wax down on to the face, a death mask was made. Seen here is a cast taken from the mask. His embalmed body was placed in a lead coffin, which in turn went into a wooden coffin.

The mask was made at a time when Cromwell was still revered by the people. But the revolution that he had helped to bring about did not survive him. After his death, there was a period of political chaos and, eventually, the Stuart monarchy was restored with Charles II in 1660.

This is the face of one of the most important figures of the seventeenth century. Oliver Cromwell was the first commoner to rule the country, and he occupies a unique place in British history. During the Civil War in the 1640s he rose from obscurity to lead the Roundheads to victory against King Charles I. When the king was executed in 1649, the country turned to their military hero and begged him to become their new leader. Reluctantly, Cromwell agreed.

During his rule (the Interregnum) religious toleration was encouraged; the Jews, for the first time since the Middle

The Great Plague

One of the most horrific years in London's history was 1665, the year of the Great Plague. Twenty-five percent of the population died, and the Museum of London holds many objects associated with this dreadful epidemic. Something of the poignancy of this time is revealed by a plate which reads 'You and I are earth'. It emphasises not only the sense of futility and fatalism that Londoners felt but also their understanding of life and death and their ability to deal with it. The silver-gilt spoon shown here is also inscribed: 'when died at London of the plague 68,596, of all diseases 97,306'.

The Museum's collection includes a series of mourning rings, which would have been worn in memory of the dead. One is inscribed inside with the words 'O my sister, O my sister' and the date, 1665.

The book seen here records 'The Diseases and Casualties this Week', covering an area of 125 parishes. This particular page records 479 deaths from the plague. Other pages show even higher figures, in the region of 6,000 a week. The iron bell on the left was rung in the street, to announce the collection of the dead or to warn that someone with the disease was approaching.

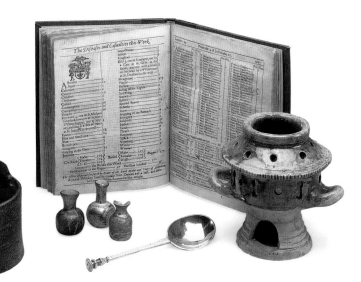

Group of plague items, 1660s

The Great Fire

Between one and two o'clock in the morning of 2nd September 1666, a fire started in Thomas Farynor's bakehouse in Pudding Lane. Within a couple of hours it had spread across the road to the Star Inn, but it seemed fairly inconsequential. Thomas Bludworth, the Lord Mayor, was roused from his bed to inspect the scene and did not feel it was cause for alarm. He is famously quoted as saying 'Pish, a woman could piss it out'. However, within a few hours the fire was fast becoming a massive inferno. Pudding Lane was close to warehouses running along the Thames that were full of combustible materials such as hemp, tar and pitch.

In addition, a high wind helped to fan the flames.

The Lord Mayor was advised to blow up houses in the fire's path to prevent it from spreading any further, but fearing litigation, he prevaricated and chose instead traditional methods. Relying on buckets and metal hand-squirts like the ones seen here, fire fighters were woefully ill-equipped to deal with a fire of such magnitude. The squirts, made of cast bronze, contained about a quart of water, and the combined weight of water and bronze made them very heavy to carry. Lines of people with buckets were easier to manage, but this did not provide anything like enough water to extinguish the flames.

The fire raged out of control. Over the course of four days, four fifths of the city was destroyed, and the extent of the damage was greater than that caused by the Blitz during the Second World War. After the fire had burnt itself out, Londoners took stock of the damage: 13,200 homes, 87 parish churches, the great cathedral of Saint Paul's, all the major commercial and municipal buildings, four stone bridges and about £2,000,000 worth of printed books and stationery were all lost.

The total loss was probably in the region of £10–12,000,000, and it took most of the second half of the seventeenth century to get London up and running again.

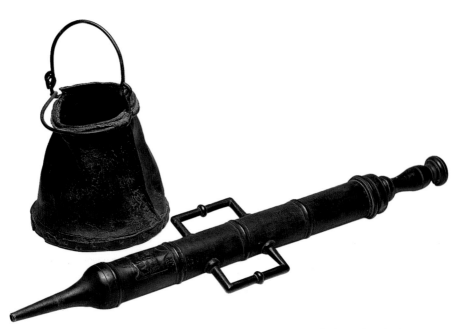

Bucket and squirt, late 17th century

The Poyle Park Room

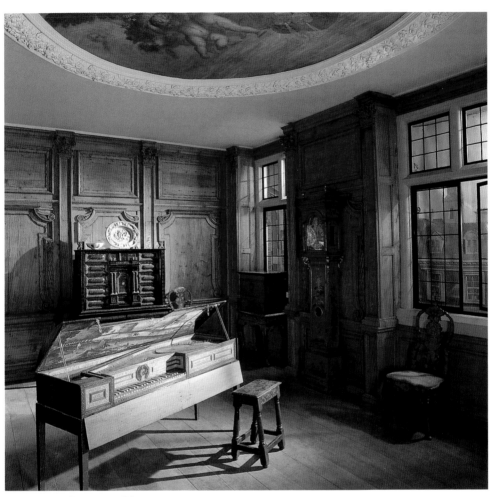

The Poyle Park Room, late 17th century

Designed in the artisan mannerist style, this room has just the sort of decor that the famous diarist Samual Pepys might have installed in his home. Although the panelling comes from Poyle Park at Tongham, Surrey, it was designed for a London merchant family and represents a typical London interior of the period. The wooden panelling on the walls is ornately carved, and the ceiling has been painted with a large personification of Summer – a winged woman surrounded by cherubs.

Apart from these adornments, the room is quite sparsely decorated. The chairs have been pushed back against the wall to make space for events during the day. Dominating the room is the magnificent virginal in the centre. Made in London, it is inscribed 'Jacobus White fecit 1656'. James White ran one of England's most important virginal-making workshops.

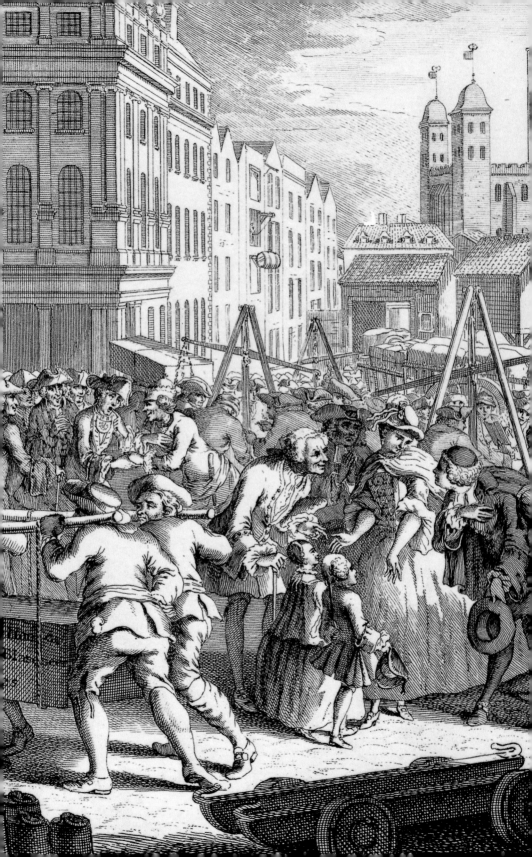

18th-century London
1714–1789

London in the eighteenth century was the administrative and economic centre of Britain. It was the biggest manufacturing centre in the country, as well as being the leading port. During the century the population almost doubled, reaching 950,000 by 1800. This rapid and unchecked expansion resulted in a huge impoverished underclass. At the same time, the century saw the rise of a middle class, professionals and tradesmen.

Many immigrants lived in London. These included Huguenots from France, who were Protestants fleeing religious persecution. They formed a core of skilled craftsmen, working in many trades from textiles to clock making. There were also economic migrants from Scotland, Ireland and the North of England.

As the population grew, wealthy members of society moved westwards to St James's and Mayfair. Further west, in areas such as Chelsea and Richmond, they built country homes. The west had clean air, agricultural land and almost no manufacturing. It was also easily reached by boat. The Thames was still an important link, as it was quicker and safer than travelling by road. Travellers crossing open land were frequently robbed.

As the aristocracy moved west, tradesmen followed them, moving out of the City of London to Covent Garden, the Strand, the West End and eventually Oxford Street. The poorer population stayed in the east, and so London's east/west divide began.

Imports of Great Britain from France, 1757, Louis Philippe Boitard. This detail shows the bustle of the port of London.

The Lord Mayor's coach

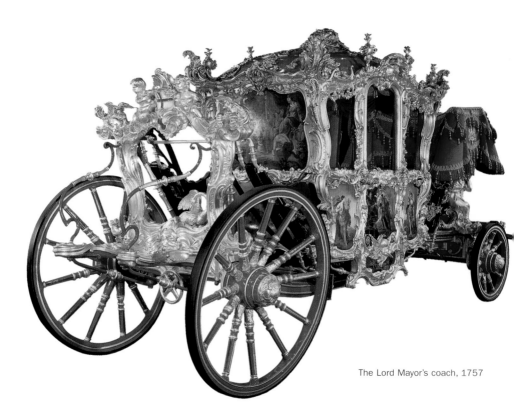

The Lord Mayor's coach, 1757

At over 2.5 miles long with 6,000 participants, the Lord Mayor's Show is the largest procession of its type anywhere in the world. It falls on the second Saturday of November, and the coach is used to transport the Lord Mayor from the City of London to the Royal Courts of Justice, in order to swear an oath of allegiance to the sovereign.

The coach we see today was designed in 1757 by the architect Sir Robert Taylor and was built by Joseph Berry of Holborn.

Building coaches was a complex business. The wooden carcase was made by the coach-maker's workmen, while he oversaw the upholstery of the seating. Carving and gilding was carried out by another craftsman; wheels were made by wheelwrights; iron treads were made by another manufacturer; and specialist brass founders made the brass fixtures and fittings.

The symbolism incorporated in the coach design alludes to the wealth and power of the City of London, with Britain's maritime trade given particular emphasis. Two carved mermen support the driver's seat, and there are many examples of carved shells and fish. A sheep's head at the front of the coach, under the driver's position, is a reference to the role of the wool trade in establishing the City's initial wealth.

The Blackett baby house

This splendid doll's house was made for Sir Edward Blackett and his wife Anne.

The bedroom contains a most spectacular piece of furniture, the four-poster bed. Hung with blue silk fabric, it has been made up with a bolster, blankets and linen. A lower mattress is filled with wool and covered in linen, while the upper mattress is a feather bed. The dressing table has an ornate mirror; there is a jug and basin for washing; and a chamber pot saves a trip to the outside privy. At the top left is the drawing room, furnished in the latest fashions of the 1750s. The Chinese wallpaper is particularly fine and the festoon curtains still have their original mechanism for raising and lowering.

Sir Edward and Lady Anne may have used the house to teach their daughter how to run a household, including how a bed should be made up, how the rooms should be arranged and how to give orders to the cook and maids. The house came with four dolls. Two are dressed in linen as maidservants. The other two are dressed as the owners of the house, or perhaps the lady of the house and a guest. All are made of linen stuffed with wood chippings and sawdust, with wax limbs and wax heads. The grand occupants of the house have glass eyes, whereas the servants' eyes are merely painted.

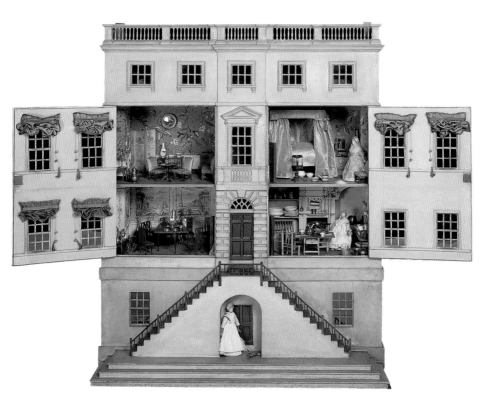

The Blackett baby house, *c*.1760

Porcelain punch bowl

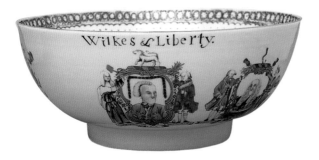

Porcelain punch bowl, 1768

Dating from around 1768, this punch bowl was made in China specifically for the British market. The bowl commemorates John Wilkes, a popular radical figure at the time. The drinking of punch had been becoming more and more popular since its introduction to Britain in the last quarter of the seventeenth century.

Punch was a convivial drink. The bowl was shared and drinkers egged each other on to 'drink the bowl dry'. There were many recipes for punch. All included spirits, making it very potent.

Child's dress

This little girl's dress is made of linen, printed with a design of trailing acorn sprays. Originally made for an adult, it was taken apart and re-made to fit a small child. This recycling of fabric is a good example of eighteenth-century thriftiness. The dress is also very faded, as a result of repeated washing.

Revolutionary new dyeing and printing techniques, invented in about 1750, were used in the production of the fabric. Using copper plates and colourfast dyes, plate printing was a major breakthrough for the textile industry. It became possible to reproduce fine lines and delicate patterns, and to create much larger repeat patterns than could be produced with wooden printing blocks. Printed textiles were enormously popular in the eighteenth century. They came in a huge range of prices, so were affordable for rich and poor alike. A major centre for printing textiles, London had printing works along several tributaries of the river Thames.

The design of this dress is similar to those produced by John Ware and John Munns in Crayford.

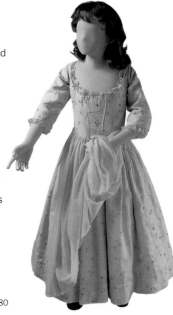

Child's printed linen dress, c.1770–80

Wellclose Square prison

Panelling from Wellclose Square prison, 18th century

The Museum houses two reconstructed rooms from an eighteenth-century prison in Wellclose Square, just east of the Tower of London. The prison was actually part of a public house, the Cock & Neptune, and the owner of the pub was the gaoler.

These rooms were the night rooms of the prison. There would also have been day rooms and an exercise yard. In some prisons there would be a number of paying prisoners who could afford to have special food and drink brought in from outside. Conditions at Wellclose Square, however, were very poor as most of the inmates were in prison for debt. Usually their time in prison was brief – most prisoners only spent between 1 and 21 days in the gaol – but this did not lessen the impact of their miserable surroundings. The walls are covered with prisoners' graffiti, a panel of which is seen here. While some carved their names, others drew pertinent images such as the gallows, or composed little rhymes.

In his novel *Pickwick Papers*, Charles Dickens described what it was like for the poorest prisoners in London's large debtors' prison, the Fleet. Although he was writing in the 1830s, he harks back to an earlier age: '… there was a kind of iron cage in the wall of the Fleet Prison, within which was posted some man of hungry looks, who … rattled a money-box, and exclaimed in a mournful voice, "Pray, remember the poor debtors; pray, remember the poor debtors".'

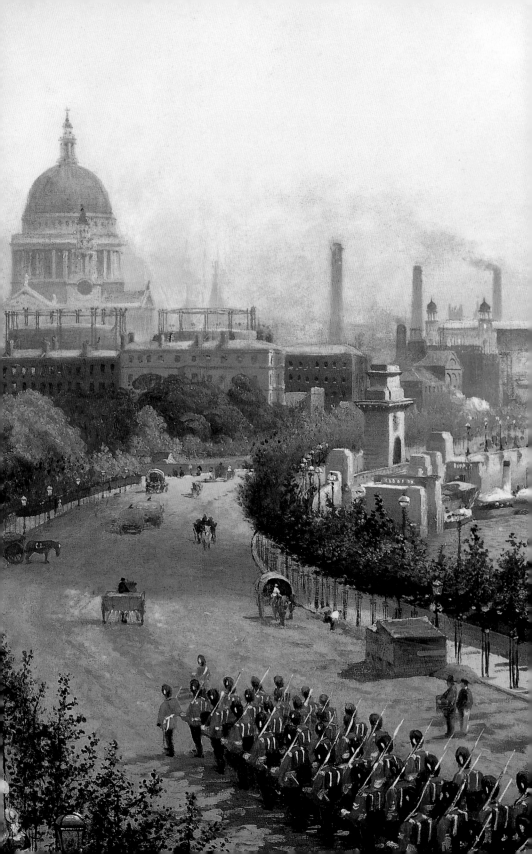

World City
1789–1914

The Museum of London's World City Gallery runs from the French Revolution of 1789 through to the start of the First World War in 1914. This was the first time that London stood at the centre of the world in terms of power and wealth. The French Revolution led to war throughout Europe, and out of this period of great political turmoil Britain emerged as the major power. When Amsterdam fell to the French in 1795, bankers moved their money and assets to London, making it the world's financial centre. Perhaps the most important conflict was the Battle of Waterloo (1815), when British troops and their allies were finally victorious. London became the pre-eminent capital of Europe and the world.

The city's economy thrived on a system of free enterprise, and the population grew dramatically from under one million to over seven million by 1914. One contemporary travel guide boasted that London had 'more Scotchmen than in Edinburgh, more Irish than in Dublin, more Jews than in Palestine and more Roman Catholics than in Rome'. So many people massed together created severe problems of congestion, pollution and disease on a scale never seen before. The Thames became a giant sewer and cholera swept through the city.

Radical improvements were needed to accommodate this massive growth in numbers. Gradually London evolved into a modern city, not so very different from the one we know today.

John O'Connor's painting of 1874 (detail) reveals the wide new roadway of the Victoria Embankment, designed by Joseph Bazalgette.

Nelson's sword

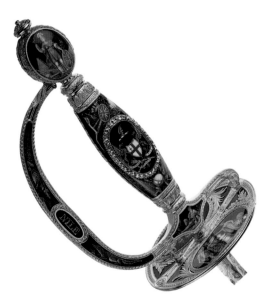

Nelson's sword, *c.*1800

Decorated with enamels and set with diamonds, this ornate sword of honour was presented to one of the greatest names in British military history, Admiral Lord Nelson. His victories against the French in the Battle of the Nile (1798) and the Battle of Trafalgar (1805) made him a national hero.

To commemorate the former victory and to express the gratitude felt by London's merchants and financiers, the Corporation of London presented Nelson with this sword in 1800. Thanks to his victory, Britain still had command of the seas – access to the trade routes, so essential to a thriving economy, had been maintained.

Newgate whipping post

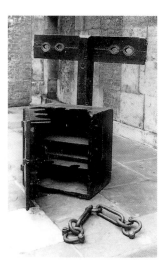

Whipping post, late 18th century

This rather gruesome object was used for punishing criminals at Newgate Prison. The offender would be locked inside the lower part, with his arms through the holes in the wooden bar above. Once inside, the recipient could do nothing to avoid the punishment of a set number of lashes.

In the mid-nineteenth century, there was general alarm at the high levels of crime in the streets of London. In particular, there was fear of garrotting, where the victim would be attacked from behind with a piece of rope around the throat. Choked and sometimes killed in the process, victims would be robbed of all their possessions. If the criminal was caught, he would be brought to Newgate Prison. A famous landmark in the eighteenth and nineteenth centuries, the prison stood to the west of the city, on the current site of the Old Bailey. Once tried and found guilty, garrotters were publicly whipped at this very post.

The General Post Office
(One Minute to Six)

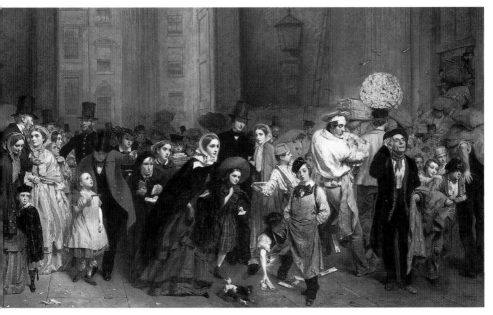

The General Post Office (One Minute to Six), by George Elgar Hicks, 1860

Here we see the Friday evening rush to catch the last post at the General Post Office – there is one minute to go. This scene came to symbolise the ever-increasing pace of modern city life, along with the importance of London's communication systems with Europe and the rest of the world.

After the introduction of the Penny Post in 1840, many more people could afford to send letters. At the same time, the newspaper stamp tax was abolished, encouraging the growth of a cheap daily press sent out by post. On the right, bags of newspapers are being thrust through the window, to be distributed to the provinces.

Sugar bowl

During the late eighteenth and early nineteenth centuries, London's black community actively campaigned for the abolition of the slave trade.

Some people used East India sugar as a substitute for West India sugar, which was tainted by its associations with slavery. The inscription on this bowl reads 'East India sugar not made by slaves'. It is not known whether such bowls were distributed by East India merchants, or by reformers anxious to promote the abolitionist cause.

Sugar bowl, *c.*1825

53

From Pentonville Road Looking West – Evening

From Pentonville Road Looking West – Evening, John O'Connor, 1884

On the left of the painting, a policeman is standing next to a postbox – each representing two new features of the Victorian period. On the corner is a newsagent's shop with advertisements around its entrance. Advertising was starting to dominate the city, and it is seen here on the sides of buildings and omnibuses. At the bottom of the picture, on the other side of the road, two sandwich-board men walk up the street. A hansom cab is in the foreground center, and a woman seems oblivious to the traffic coming towards her as she tries to cross the busy road.

This painting brilliantly evokes the atmosphere of life in the Victorian city. In the centre are the Gothic spires and clock tower of the Midland Grand Hotel at St Pancras Station and, beside it, the huge vaulted roof of the actual station.

Hansom cab

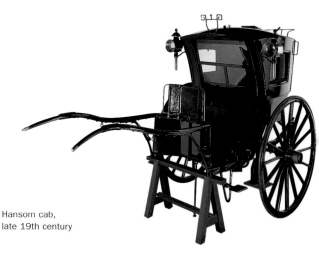

Hansom cab,
late 19th century

This is perhaps the vehicle that most vividly embodies Victorian London for us today. The cab's design was patented by Joseph Hansom in 1834, and at first it was not very popular. Its startling innovations included two large wheels instead of four smaller ones, and a driver's seat perched up at the back. However, passengers soon began to see the advantages. Pulled by just one horse, hansoms could speed up very fast if there was a clear space, and they could come to a halt very quickly too. They were nimble at getting round obstacles in the street and could squeeze down narrow alleys. It was easy to communicate with the driver through a panel in the ceiling, and the passenger had a wonderful view of the city as they were whisked to their destination. It was also a very private means of transport. By the 1880s there were thought to be over 10,000 on the streets of London.

Suffragette banner

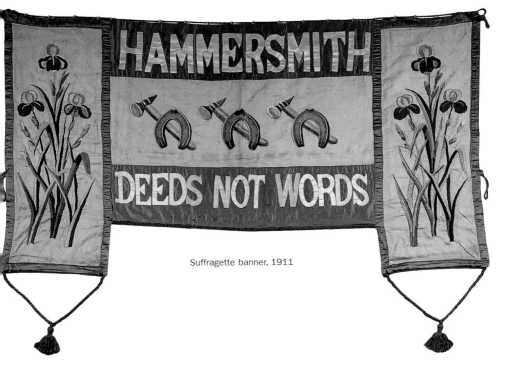

Suffragette banner, 1911

'We are here, not because we are law-breakers; we are here in our efforts to become law-makers.'

– Emmeline Pankhurst

These words were spoken by Emmeline Pankhurst, one of the leaders of the women's suffrage movement, which emerged in the late nineteenth century. Reforms had extended the franchise to nearly all men, regardless of their status, and many women felt the time had come for women to have the vote too. Changes in working practices in the new industrial world had brought about more opportunities for women.

Much of the campaign took place in London. Demonstrators would carry banners like the one shown here, representing the movement in Hammersmith. It bears the slogan of the militant Women's Social and Political Union: 'Deeds Not Words'. The suffragettes were certainly known for their deeds – chaining themselves to railings outside the Houses of Parliament, hunger striking and even suicide. They were often handled roughly by the police and repeatedly jailed and fined. The struggle for the vote lasted for several decades, finally culminating in victory in 1928.

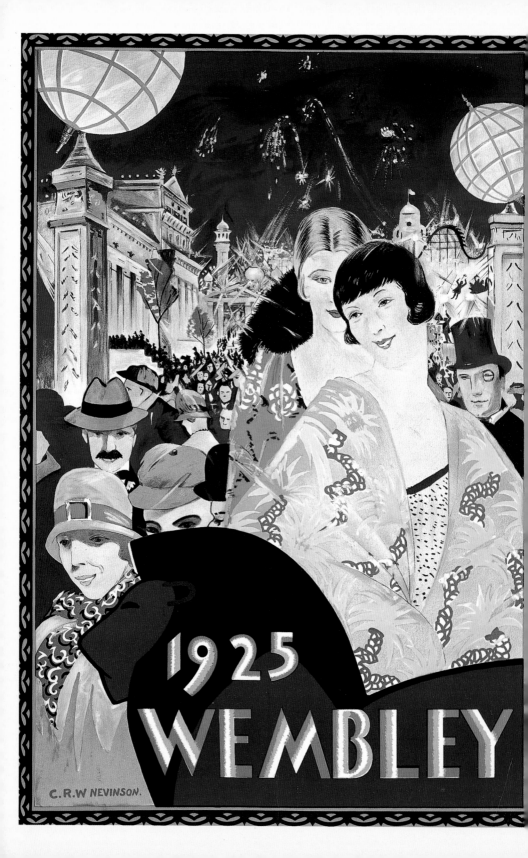

1925
WEMBLEY

C.R.W NEVINSON.

20th-century London

1914–2000

London saw unprecedented changes in the years after 1914. Technology, democracy and globalisation brought cars, television, cultural diversity, new freedoms, public services and skyscrapers to the city. Technology also brought warfare into the heart of London, and the city suffered bomb damage in both world wars (1914–18 and 1939–45). The intensive 'Blitz' bombing of the Second World War was particularly traumatic for those who lived through it.

The twentieth century saw London grow to its largest-ever size, with a population of over eight million in Greater London recorded by the census of 1931. This increase in population was also mirrored on the ground, with suburban housing estates extending London's boundaries until such growth was curbed by the introduction of 'green belt' legislation.

Between the wars London escaped much of the depression that afflicted the traditional heavy industries in the North. After the Second World War, changes in the global economy led to the collapse of London's traditional sources of employment. London's inner-city docks closed from the late 1960s onwards, leaving 'Docklands' in East London to become a large area of redevelopment during the 1980s and 1990s. Globalisation also made London a more culturally diverse city as people from all over the world made their homes in London, injecting a new vigour into the city's life and culture.

Poster for the British Empire Exhibition, C. R. W. Nevinson (1889–1946)

Evening in the City of London

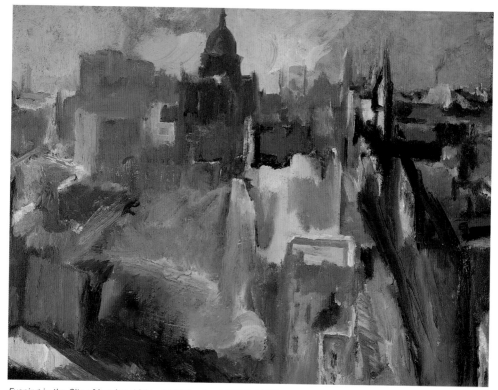

Evening in the City of London, 1944. David Bomberg (1890–1957)

Born into a Jewish family in Whitechapel, David Bomberg studied art at the City and Guilds Institute, the Westminster School of Art and the Slade. A founder member of the London Group, he was one of Britain's leading avant-garde artists before the First World War. He taught at Borough Polytechnic from 1945 to 1953, and was an influential teacher, whose pupils included Frank Auerbach and Leon Kossoff.

The painting records a scene of devastation, yet its warm tones create a sense of optimism. Painted from the tower of St Mary-Le-Bow, the view stretches from the river, on the left of the picture, to the area north of Cheapside and Newgate Street shown on the right. The dome of St Paul's cathedral dominates, emphasising its iconic status in wartime London.

Bomberg believed that paintings should capture the expressive essence of the subject, evoking the spirit of a place as well as its appearance, and this painting is a good example of his artistic eloquence.

In service in the 1920s

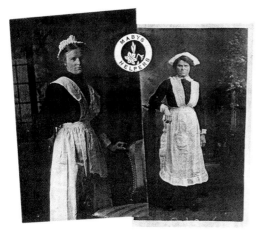

These women were residents of a home run by the Metropolitan Association for Befriending Young Servants (MABYS). This was a charitable organisation that offered accommodation and moral guidance to servant girls in London. The photographs came from an album donated by Louise Lenton, who worked for the association.

Photograph of two servant girls, 1920s

Lifts at Selfridges

These highly decorated lifts were installed in Selfridges department store in 1928. Wrought iron and bronze were used for the interior panels, to a design by French artist Edgar Brandt, while the exterior panels of painted bronze were by C. A. Llewelyn Roberts.

The lifts were operated by young women wearing trousers, which caused comment at the time. Some of the girls went on to marry well-to-do customers.

By 1939 the store had twenty-nine passenger lifts and seventeen freight lifts. Half were put out of action in the Second World War, and after the war the 'lift girls' were gradually replaced by disabled ex-servicemen. In 1952 it was

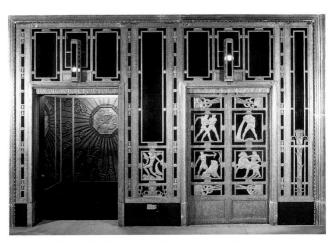

Selfridges lifts, 1928. Made by the Birmingham Guild Ltd.

calculated that a single lift travelled $4\frac{1}{2}$ miles in a day, and that its door opened and shut 2,000 times. About four million passengers were carried by the lifts in that year.

Selfridges was listed as a Grade 2 historic building in the early 1970s. The lifts were removed in 1978, after permission had been obtained

from the Historic Buildings Commission. The decorated doors, cages and their surrounds were split up, with parts going to the Archives Room in Selfridges, the Museum of London, the Victoria and Albert Museum, the Brighton Museum and a private house in Buckinghamshire.

Ford Cortina

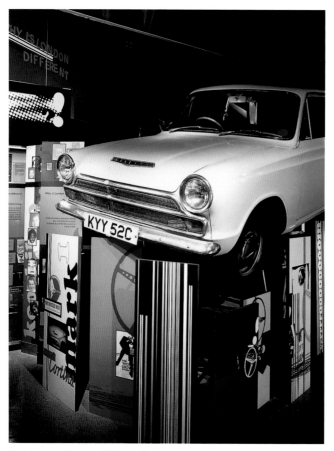

Ford Cortina, Mark 1, 1965, as displayed in the Museum's *London Now* gallery 1997–2000.

The Ford Cortina was one of the great success stories of London manufacturing in the 1960s. The basic model was introduced in 1962 and sold for £636. The Ford factory had opened in Dagenham in the early 1930s, and by the 1960s it was one of London's largest employers. One million Cortinas were made at the factory during the 1960s.

During the first years of manufacturing the Cortina, Ford introduced many new innovations, including the dashboard with vents at each end, linked to the heating system, which could also feed in cool air. In 1965 they added seat belts to the car.

Seen as the youthful, trendy car of the 1960s, the Cortina was reasonably cheap and deliberately styled to look modern and new.

The Blitz

The photograph shown here is one of 350 or so images taken by two police constables, Arthur Cross and Fred Tibbs, between 1940 and 1945. Their pictures show the severe damage caused to the City of London by German air raids, and document the efforts of the fire and rescue services to deal with the aftermath.

Arthur Cross was the City of London Police Department's official photographer, appointed in July 1939. A police constable with a keen interest in photography, Cross was ordered to take identity photographs of every member of the City of London Police Force when war with Germany was declared in September 1939. When the first German bombs began falling on London, in September 1940, Cross was told to photograph the damage caused by the air raids in order to provide an aid to reconstruction. What subsequently became known as the 'Blitz' began as a series of night-time air raids, which were not expected to continue for more than a week or two. Cross supposed his work would be completed within a month, and he was assigned an assistant, P.C. Fred Tibbs, to complete the job as quickly as possible. Tibbs, holder of the King's Police Medal for Bravery, was also a keen amateur photographer. Following his family's evacuation to Wales, he decided to 'live-in' at Bishopsgate Police Station, and was frequently on the scene following an attack, camera at the ready, within a few minutes of the 'All Clear' being sounded.

In fact a period of intensive night-time bombing continued for many months, wiping out more than a third of the City of London, before the campaign was called off in May 1941. For the duration of the war, Cross and Tibbs kept up their record of bomb damage to the city going well beyond the call of duty. With one or two exceptions, it is now impossible to tell who took which photographs, but their collective work provides a unique visual record of the damage inflicted upon the City of London during the Second World War.

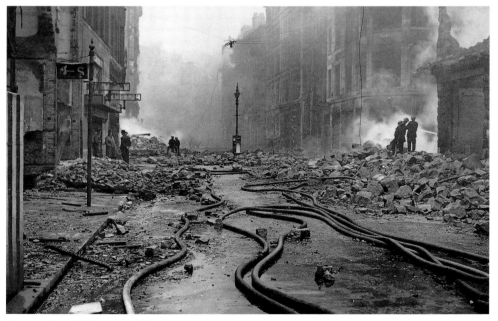

Newgate Street, 29 December 1940

Make-up in the 1970s

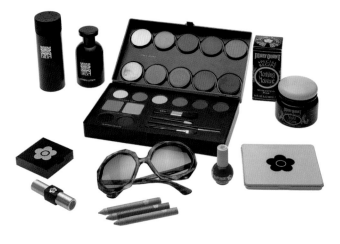

Mary Quant's boutique 'Bazaar' opened in the King's Road in 1955. She came into her own in the early 1960s when her bright, pop-culture clothes caught the mood of the times. Quant was the fashion equivalent of the Beatles in terms of her influence and her worldwide success. The shop Biba opened in Kensington in 1964 and also had a strong influence on youth culture. Both Biba and Mary Quant produced ranges of colourful cosmetics and accessories, and these continued to be produced after the closure of the original shops.

Mary Quant and Biba items, 1970s

Collecting 2000

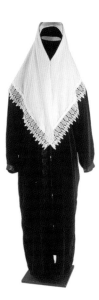

This major project focussed on groups and societies in London. The Asian Women's Advisory Service donated this hijaab, explaining that its name comes from the Arabic word 'hajabah', meaning to hide or conceal. This describes the practice of dressing modestly, with head and body covered. Wearing hijaab creates a situation where a woman is less likely to be exploited for her beauty. Not having to be concerned about her appearance, the wearer is free to concentrate on her tasks and can also feel secure and protected.

Items of dress from many cultural traditions are an everyday sight in London today. In 1991 London was home to nearly 1.35 million people belonging to an ethnic minority group, making up 20 per cent of the city's population. London has 45 per cent of the U.K.'s ethnic minority population, compared to 12 per cent of the country's total population.

Hijaab, 2000. Donated to the Museum by the Asian Women's Advisory Service

History Painting

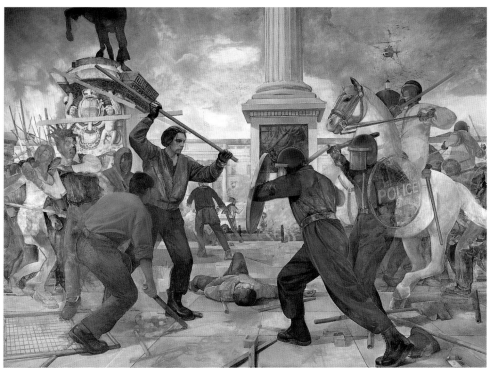

History Painting, 1993–4. John Bartlett (b.1960)

This painting takes as its subject one of London's most memorable events of recent years. The 'Poll Tax riot' erupted in Trafalgar Square in March 1990. It had begun as a peaceful demonstration against a tax that seemed to take little account of differences between rich and poor. The artist depicts the dramatic scene in a deliberately traditional style, and he has given his painting a timeless and mythical quality by including many references to great works of art from the past. There are strong echoes of battle scenes by the Renaissance artist Ucello in the arrangement of the figures, weapons and horses.

Painted between 1993 and 1994, *History Painting* was not conceived from any specific political standpoint, but rather as a record of a London event and as an exercise in depicting conflict. The Metropolitan Police helped the artist by lending him uniforms to paint in his studio.

Because of its subject matter the painting was controversial when first hung in the Museum.

Visitor information

Recorded information
Telephone 0870 444 3851

Opening hours
Mon to Sat 10am–5.50pm, Sun 12–5.50pm
Last admission to Museum 5.30pm

Smoking, eating and drinking are not allowed
in the galleries.

Shop
The Museum shop stocks a wide range of
gifts and souvenirs relating to London and
its history, as well as over 1,000 book titles,
including specialist and academic publications
and an extensive selection for children.
For enquiries and mail order:
Telephone 020 7814 5600
E-mail shop@museumoflondon.org.uk

Café
The café offers a range of drinks, hot lunches,
sandwiches, snacks and salads.

Disabled access and facilities
All the Museum's galleries and facilities are
accessible to wheelchair users. Touch tours
and audio tours are available at the Admissions
desk. Guide and assistance dogs are welcome.
For details of BSL interpreted talks and events:
E-mail info@museumoflondon.org.uk

Over the next two years the Museum is
embarking on a series of major refurbishments
to its entrance and galleries. Access to parts of
the Museum may be affected at certain times.
For exact details prior to your visit:
Telephone 0870 444 3852
E-mail info@museumoflondon.org.uk

Education and events
The Museum offers a full programme of events
for families and adults, including workshops,
demonstrations and study days. Services for
schools and colleges include object handling,
storytelling, AS/A Level conferences, evening
classes and teachers' courses and resources.

For full details of current programmes:
Telephone 0870 444 3850
E-mail info@museumoflondon.org.uk

Group visits
School and college groups, and adult groups
of ten or more, are requested to book their
visit to the Museum in advance of their arrival.
Telephone 0870 444 3850
E-mail groups@museumoflondon.org.uk

Picture Library
The Picture Library holds over 35,000 images
illustrating the history of London and its people.
To request a search or to order transparencies,
prints or slides: Telephone 020 7814 5605
E-mail picturelib@museumoflondon.org.uk
Digital images from the Museum's collections
can be ordered from www.heritage-images.com

Filming
The Museum buildings and galleries provide
a unique location for filming. For details of
conditions and fees: Telephone 020 7814 5605
E-mail picturelib@museumoflondon.org.uk

Venue hire
Venue sales will resume for the new Theatre
which launches in Autumn 2008, and for the
new galleries from Autumn 2009. The website
will carry regular updates on hire opportunities
from Spring 2008. Meanwhile, facilities for
conferences, receptions and fine dining
remain available at Museum in Docklands.
For further details or to request a brochure:
Telephone 020 7001 9816
E-mail specialevents–mid@museumindocklands.
org.uk
www.museumindocklands.org.uk/specialevents

Supporting the Museum of London
For information on how to become a Friend
of the Museum of London or how to become
involved in the Museum's development
programme as a corporate partner or sponsor:
Telephone 020 7814 5507
E-mail development@museumoflondon.org.uk